Ornamental Lettering

Text and drawings by Catherine Auguste

SEARCH PRESS

The author continues to run her original web site dedicated to painted furniture (www.meublepeint.com). She also has a new site for those interested in ornamental lettering (www.enluminure.com) and every year organises courses in lettering and illumination. E-mail: catherine.auguste@cabinet-maker.com

First published in Great Britain 2007 by Search Press Limited, Wellwood, North Farm Road, Tunbridge Wells, Kent TN2 3DR

Originally published in France 2003 by Éditions Ouest-France — Edilarge S.A., Rennes

Publisher's code: 4724 01 07 10 04
Dépôt légal: April 2003 — Printed in France

English edition typeset by GreenGate Publishing Services, Tonbridge, Kent

Printed by Mame Imprimeurs, 49 Boulevard de Preuilly, 37000 Tours, France

Photograph credits:

Introduction

4 © BnF, ms. lat. 9389, f° 18 v°. Echternach Gospel, 8th cent.
5 © BnF, ms. lat. 12135, f° 1 v°, St Ambrose, Hexameron, 9th cent.
5 © RMN/Gérard Blot, initial B with St Luke. Paris, Musée du Moyen Age, Cluny.
6 © BM de Dijon, ms. 170, f° 59, St Gregory the Great, Moralia in Job, 12th cent. Photo: F. Perrodin.
7 © RMN/René-Gabriel Ojéda. La Très Élégante Histoire du Roy Perceforest, 16th cent. Chantilly, Musée Condé.
8 © BM d'Auxerre, ms. 17. St Jerome illustrating a rubric in red ink.
9 © BM d'Avranches, ms. 72, f° 151, works of St Jerome, St Augustine and St Ambrose.

Chapter photographs

11 © Le Scanff—Mayer, plum tree.
32 © Nicolas Franck. Lion, symbol of St Mark; eagle, symbol of St John, 11th cent., Serrabone Priory (66).
54 © Hermann Lersch. Original ironwork, 12th cent., from door of the Église Saint Jean-Baptiste, Saverne (67). © RMN/H. Lewandowski. Stained glass window. Roundel with monogram LG, c. 1450—60, attrib. Jean Fouquet.

The majority of the illustrations in this book are by Catherine Auguste.

Contents

Introduction

Ornamental lettering: the basis of illumination

Illumination is a generic term encompassing all the decorative elements found in medieval manuscripts. There are three types:
— Miniatures, a small painting inserted in the body of the text, either at the start or in the middle of a page;
— Borders, which originate from the initial, sometimes extended to frame the page;
— Initials themselves. They are known as 'historiated' when they depict scenes or events and 'zoomorphic' when illustrating animals or fabulous beasts.

The birth of ornamental lettering

In classical times text was designed to be read aloud. Initials might signal a division in the text or be placed in isolation at the top of the page. With the spread of Christianity, pride of place was given to the presentation of the Gospels. The way text was viewed changed: it became a visual commodity and demanded ornamentation. Decorations provided not only signposts in the text for the eye but also embellished religious writings for the greater glory of God. Ornamental lettering reached its apogee in the Middle Ages between the 7th and 12th centuries, a period in which monastic communities were producing great quantities of manuscripts. Other factors contributed to its development:
— the replacement of the papyrus roll, or volumen, by the codex from the 2nd century AD. The codex was a collection of sheets made of animal skin and bound together, the forerunner of the book as we know it;

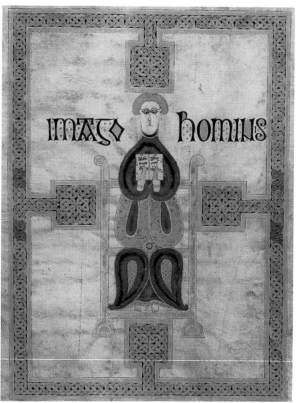

Above: Man, symbol of St Matthew. Echternach Gospel, 8th cent. BnF, ms. lat. 9389, f° 18 v°.

Opposite page, left: Detail from the Hexameron of St Ambrose. 9th cent. BnF, ms. lat. 12135, f° 1 v°.

Opposite page, right: Initial B with figure of St Luke. Northern France, second half of 9th cent. Musée du Moyen Age, Cluny, Paris, RMN.

— the diversification of types of book, such as the breviary, antiphonary, book of hours, psalter, bible, gradual, herbal and so on;
— the widening interest in reading and the heightened status associated with possession of books.

Styles and influences

The insular Celtic style

The oldest illuminated manuscript known is a few leaves of a text by the Roman poet Virgil, and it dates from the late 4th century. However, there is no doubt that it was the monks of Ireland — a country never conquered by the Romans — who first developed a regional style of manuscript known as the Celtic insular and characterised by the adaptation of traditional Celtic decorations to the new religious texts. The ornamentation consisted in the main of abstract compositions (spirals and knots) and scatterings of fantastic animals and letters surrounded by red dots (*pointillé*). The colours used were simple: blue, green and red, with yellow substituting for gold. The designs were so invasive as to give rise to the term 'carpet page' decoration. The *Lindisfarne Gospels* (c. AD 700) and the *Book of Kells* (c. AD 800) are the oldest examples preserved today. The spread of this insular style of art, first thoughout England, and then to the Continent around the 9th century, began with the Viking invasions and enjoyed a constant impetus from the fervour of British and Irish missionaries.

The classical Carolingian influence

In Gaul, there was a blending of influences: Mediterranean sources were combined with trends imported from Britain and Ireland. The large Irish initials, often historiated, became the norm. Charlemagne was the first to install scriptoria close to his court, giving them a remit to return to classical sources. Attempts were made to render perspective while the illuminators' palette grew broader, as in the Gospels of St Médard of Soissons. At the same time, the Carolingian emperor encouraged the adoption of a smaller and more rounded form of script now known as Caroline or Carolingian minuscule. The characters bore greater resemblance to continuous writing, resulting in a more marked separation of paragraphs and chapter headings. This script left extra space available for the initial. This attempt at rationalisation did not spell the end of illumination, though it remained a luxury in the 9th century, the centres of production being dependent upon commissions from sovereigns and their entourages.

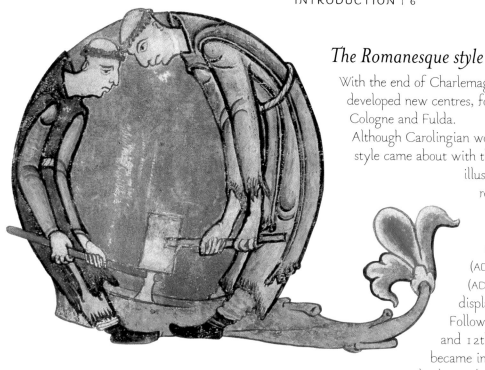

This page: St Gregory the Great, Moralia in Job, 12th cent. BM de Dijon, ms. 170, f ° 59. Photo: F. Perrodin.

Opposite page: La Très Élégante Histoire du roy Perceforest, vol. i: Illuminated frontispiece.

16th cent. Illumination on parchment. Musée Condé, Chantilly, RMN

The Romanesque style

With the end of Charlemagne's empire, his Ottonian successors developed new centres, for instance in Trèves, Reichenau, Cologne and Fulda.

Although Carolingian works continued to be copied, a change in style came about with the arrival of artists from the east; the illusion of perspective disappeared, to be replaced by simplified, stereotyped figures standing out against gold backgrounds. Colours remained opulent, as in the *Gospels of Otto III* (AD 998) and the *Bamberg Apocalypse* (AD 1000), with the iconography displaying a Byzantine influence.

Following the monastic expansion of the 11th and 12th centuries, illuminated manuscripts became increasingly diverse: in addition to gospel books, psalters, apocalypses, lives of saints and books of hours abounded. Most manuscripts were still the work of monks whose primary intention was to glorify God; realism was not a priority.

The development of Gothic

The start of the 13th century was marked by an important change in style with the appearance of secular 'ateliers' in urban locations. With the support of Louis IX ('St Louis'), Paris became the European centre for the production of illuminated work. The majority of commissions now came from laymen rather than the Church; the output was still books of hours, psalters, and so on, to which were added histories and chronicles, classical texts, bestiaries, herbals and romances such as *King Arthur and The Knights of the Round Table*. What amounted to an explosion in demand was a response not only to the nobles' taste for collecting illuminated manuscripts – Charles V's 'library' being one example – but also to the requirements of the universities.

Although illumination continued in the Romanesque tradition with abstract backgrounds and trellis, diaper, or plain gilded decorations, it is possible to see a stylistic evolution towards greater realism. The figures are treated less systematically, gaining in elegance and adopting *déhanché* postures, yet their facial expressions remain frozen. We also find attempts at perspective in interior scenes. Gothic minuscule is difficult to read: so prolific is the use of the ogee, as borrowed from contemporary architecture, that many letters resemble one another.

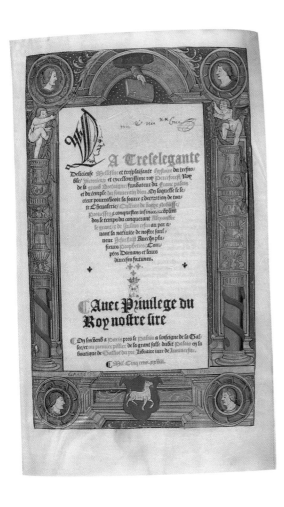

Towards the Renaissance: a golden age and the advent of realism

In the 14th and 15th centuries, idealism was gradually replaced by realism, leading, for example, to the proliferation of landscape backgrounds. There was a desire to reproduce nature faithfully and to portray everyday life as it was; this is evident not only in miniatures but also in ornamental lettering, with margins swarming with decorative leaves, animals and grotesques. Books of hours became popular with both the nobility and the bourgeoisie, and were produced by celebrated lay artists: the brothers Limbourg illustrated *Les Très Riches Heures du duc de Berry* (1413–16) and Jean Fouquet the *Heures d'Étienne Chevalier* (1452–60). Such works already foreshadowed the Renaissance, changing tastes clearly visible in the relief effects, medallions, acanthus and laurel wreaths. The principle artistic centres of illuminated work in this era were Paris, Venice, Florence, Ghent and Bruges.

The invention of printing

Ornamental lettering as an art form lasted into the 14th century despite the invention of printing, and Albrecht Dürer (1471–1528) was illustrating the *Book of Hours of Maximilian I* in c. 1512. It was not until the 17th century that the art form became extinct in Europe, when the techniques of engraving on wood, then metal, allowed initials to be incorporated as typographical elements. This opened the door to the creation of whole alphabets reproducible as and when required. The world gained more alphabets – but lost the glowing colours and the personalisation of the letter within the text.

The illuminator's materials

The gradual adoption of parchment – treated animal hide – contributed to the development of illumination and made it possible to bypass the Egyptian monopoly on papyrus. The reed *Cyperus papyrus* grows mainly on the Nile marshes, whereas calves, sheep and goats, from whose skin the new material was made, were to be found in every country. Parchment also offered a number of advantages: it tolerated several layers of paint; both sides could be used, and, unlike papyrus, it did not degrade with moisture, though the lengthy preparation process from tanning to scraping made it a costly material. Eventually, a cheaper rival appeared in the form of paper from the 15th century onwards.

Medieval illuminators used a wide variety of pigments derived from animal, mineral or vegetable sources, including ultramarine (from lapis lazuli), orpiment yellow, cinnabar red, murex purple and malachite green. Once powdered and filtered, these pigments were combined with a binder such as gum arabic or egg white. Several applications were needed, with very little blending of pigments, successive light layers being added until the required density was obtained. These pigments aside, the material *par excellence* was gold, which is extremely stable; indeed, the word 'illumination' is derived from the Latin *illuminare*, 'to make bright'. Gold was employed extensively until the 14th century under the influence of religion and the desire to glorify God, but gradually lost its appeal as iconography became more realistic.

Below: St Jerome illustrating a rubric in red ink. BM d'Auxerre, ms. 17.

Opposite page: Works of St Jerome, St Augustine and St Ambrose. BM d'Avranches, ms. 72, fº 151.

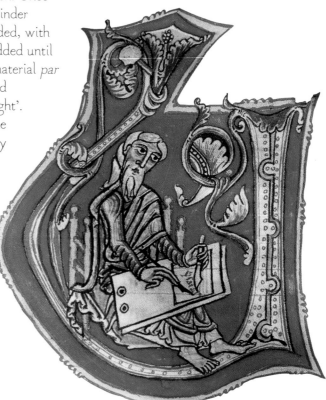

Technical tips

To complement the advice you will find throughout the book, here are a few tips on copying the medieval illuminators' techniques that enabled them to produce work of such outstanding freshness.

Paper – the 'foundation'

You will need a heavyweight paper as it will be soaked by successive layers of colouring; 360 g Arches coated paper is particularly suitable because its velvety surface closely approximates to parchment. So as not to spoil the surface by too much rubbing out, prepare your initial on tracing-paper and then transfer it to your sheet.

Colours

A simple assortment of gouache colours is sufficient. Medieval illuminators used gum arabic, which is nothing more than the binding agent for gouache. Don't use too many colours: it's a waste of time. Try:

two cadmium yellows (one dark, one light),
two cadmium reds (one light and one dark; vermilion and carmine, for example),
cobalt blue,
ultramarine,
emerald green,
white,
one or two earths, e.g. raw sienna and burnt umber.

Avoid black gouache: it muddies the colours. You can make a very attractive black by mixing carmine red, ultramarine and a pinch of umber earth. According to the proportions used you will end up with a warm black – with undertones of red, blue or brown – and a much richer effect.

Templates for some of the illustrations in this book can be found at the back, on pages 94–101.

Flowers,
leaves and branches

In architecture, precious metalwork and embroidery, stalks and foliage were more significant than the flowers themselves. Illuminators would have copied their representation from the other arts, and by observing nature, discovered a multitude of shapes and forms ideal for their own work. Acanthus, vines and ivy were the most popular organic subjects, often stylised to the point of being unrecognisable.

Constructing a motif

Initial L with plant motif

This L with plant motif is drawn from a 15th-century English manuscript illustrating the construction of decorated letters and borders. The first books of this type appeared in the 12th century and included complete penned alphabets and instructions on how to colour them. In this example the colour choices are our own.

Prepare the tracing using a mechanical pencil.

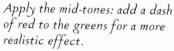

Apply the mid-tones: add a dash of red to the greens for a more realistic effect.

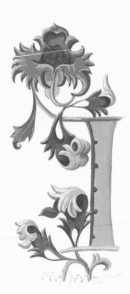

Add shading in the hollows of the leaves and serrations of the petals using green mixed with some ultramarine.

The motif has taken shape: all that remains is to give it a luminous effect using touches of pale blue for the flowers and a near-white green for the foliage.

Experimenting with colour

Initial N with white vine

Here is an initial from the 16th-century French Renaissance — a descendant of the white vine motif. This decorative motif was also typical of the Florentine Renaissance: the initial is interlaced with a climbing white vine on a coloured background colour.

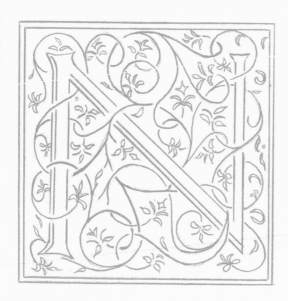

The network of branches is fairly dense; the stem generally appears truncated, or springing from the letter. A pattern of dots in contrasting colour is applied as a final touch to enhance the background.

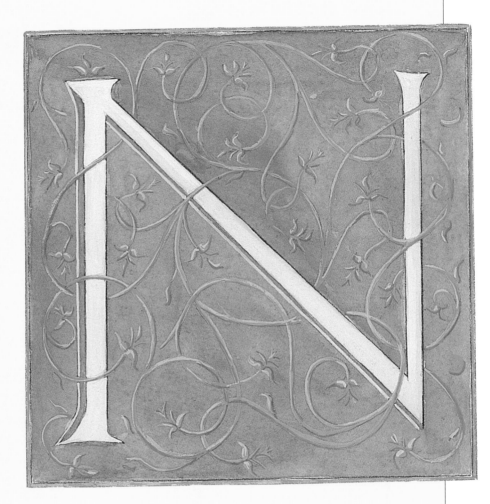

Experimenting with form

Initials with Sweet William flower

You can make all sorts of letters out of a tree trunk by adding branches at strategic points. In addition the bark can be made to look like that of a cherry tree (grey, darkish purple) or a conifer (brownish) and so on.

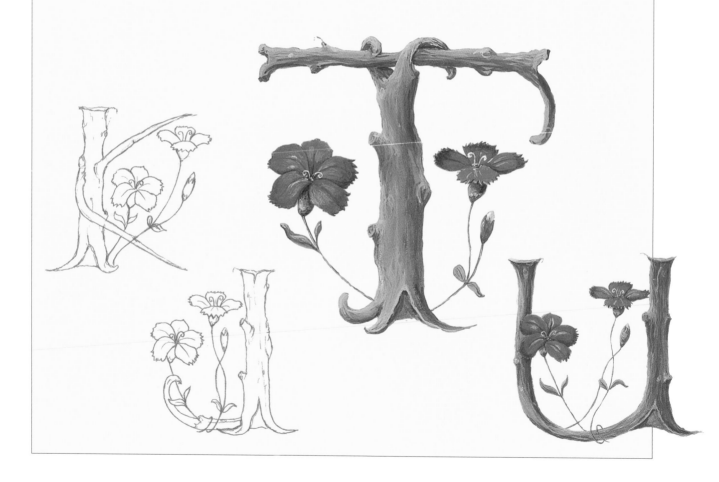

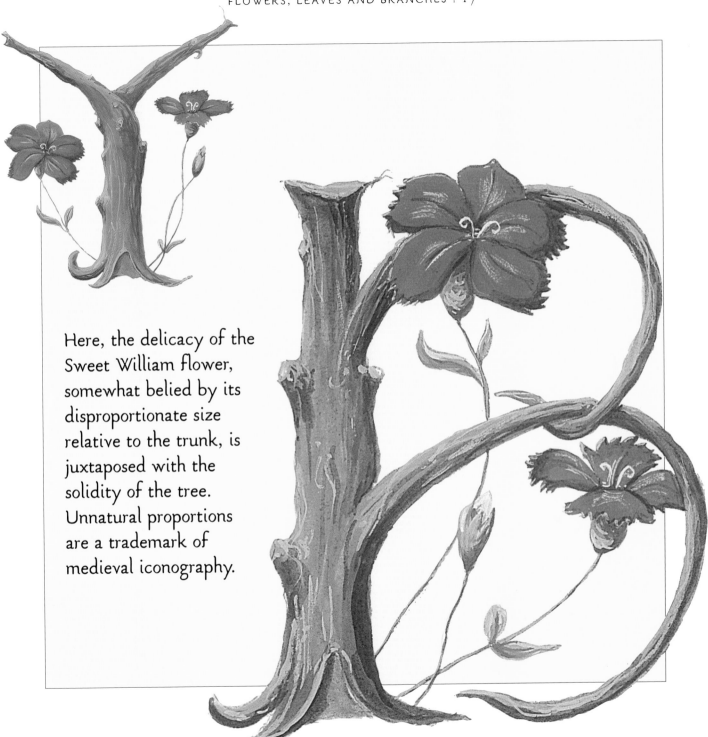

Here, the delicacy of the Sweet William flower, somewhat belied by its disproportionate size relative to the trunk, is juxtaposed with the solidity of the tree. Unnatural proportions are a trademark of medieval iconography.

Prepare your tracing paper with a mechanical pencil.

Trace the inner square with a pencil and colour it with a dense blue (ultramarine mixed with cobalt blue and a dash of cadmium red); then, using the traced lines, transfer the motif onto this background.

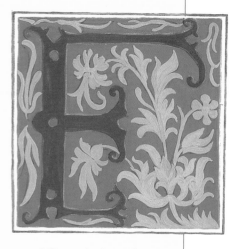

Carefully apply the mid-tones of the F and the foliage.

Constructing a motif

Initial F of type used in the *Roman de la Rose*

Begun by Guillaume de Lorris in 1230 and completed by Jean de Meun in 1275, the *Roman de la Rose* is an allegorical tale on the themes of courtly love and philosophy in the 13th century. It enjoyed continuous success before becoming a work of reference during the Renaissance. This F is taken from a 16th-century French work.

To add depth, base the shadows on an earth tone (sienna plus umber); first, though, you will need to choose the direction of the light. In decorative art, light most often falls from the upper left-hand edge (northwest on the compass). Note how, on the detail above, the shadow falls on the opposite side of the leaves (i.e. southeast on the compass).

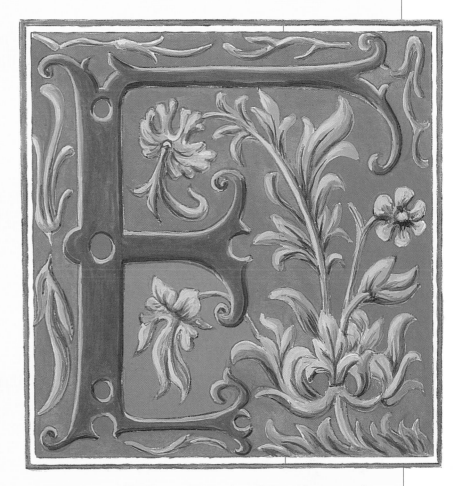

Finish by adding highlights with a bright yellow on the crests of the initial and a near-white yellow on the foliage.

Experimenting with colour

Initial V with convolvulus

Taken from a 15th-century French initial engraved on wood, this V is typical of classical Roman influence: it appears to be carved in stone. During the Renaissance, painters took care to portray subjects realistically — here the slender convolvulus twines carelessly inside the frame, much as it would in nature.

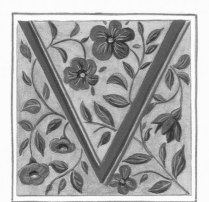

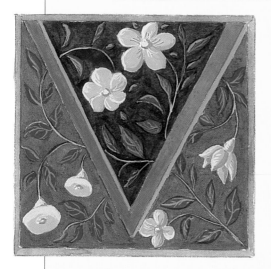

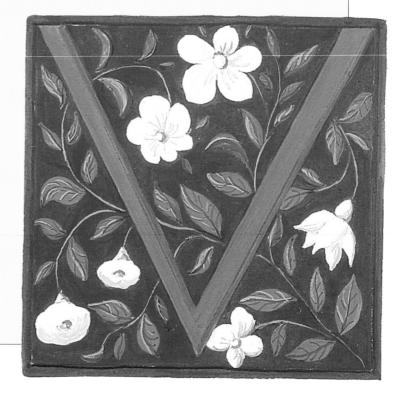

For each example trace the square and the V with a mechanical pencil before applying colours to the background and the initial; then transfer the organic motif using the tracing paper. Apply the mid-tones of the foliage and flowers; then add the final touch with shadow effects.

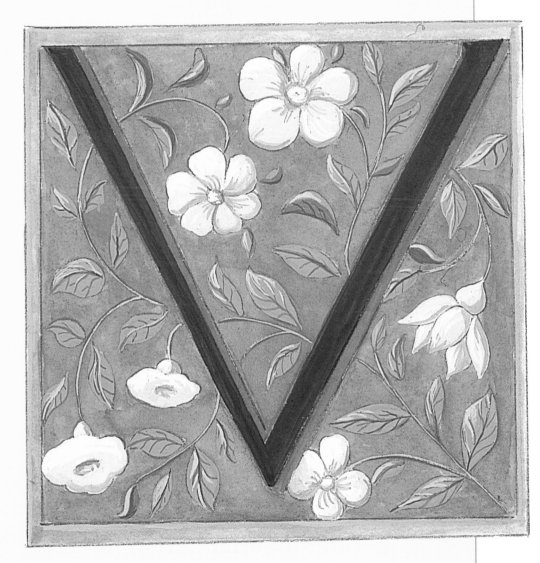

Experimenting with form

Initials with acanthus

From ancient times, the acanthus has figured prominently in decorative art, doubtless owing to its wonderful 'plasticity'. Creeping, climbing, naturalistic or stylised, trailing or in swags and scrolls, you will find it everywhere in sculpture, painting and architecture.

It's simple to make an acanthus initial: study a few specimens to see how the leaves curl.

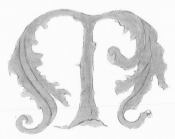

Each scroll consists of straight or extended sections that can serve as a base for the vertical elements of the initial.

To these straight sections add branching stems that can be shaped to suit the initial.

Paint in the mid-colour, here a gold tone composed of cadmium yellow and cadmium red.

To make your motif more vibrant, pick out the veins with a darker tone and add a few highlights using cadmium yellow plus white.

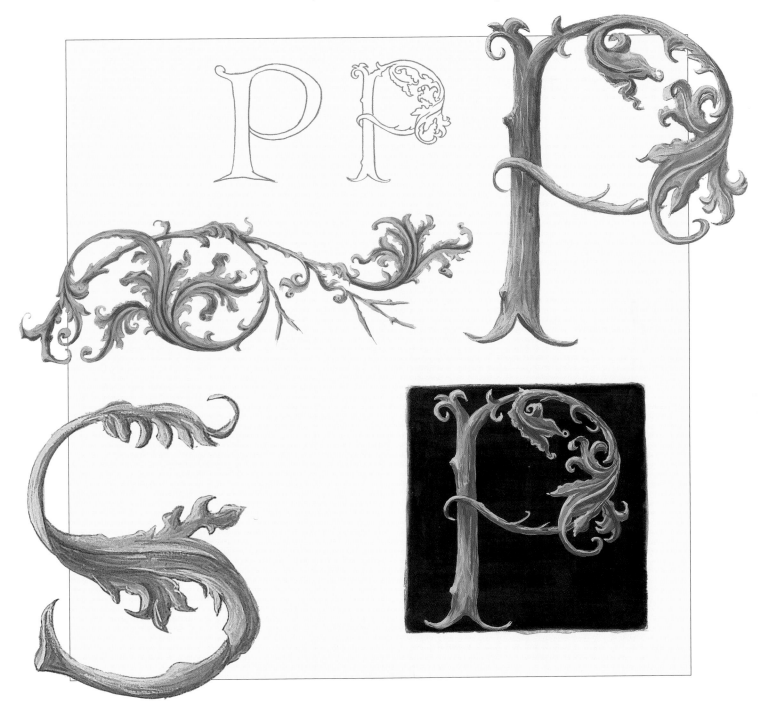

Constructing a motif

Initial A with spring flowers

An initial A from the 16th-century German Renaissance
displaying the symmetrical arrangement typical of the period.

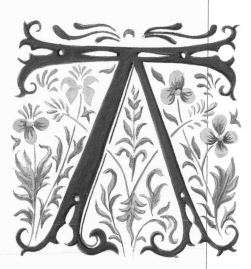

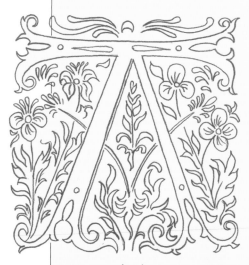

*Prepare the design on tracing
paper with a mechanical pencil.*

*Once the motif has been
transferred to the drawing
paper, using light brushstrokes
to add all of the mid-tones to
each element.*

*For the shadows, use a darker glaze: one technique
consists of adding a little ultramarine to the mid-value.
The light should appear to come from the upper left
border (northwest on the compass), so place the shadow
tones on the opposite side (i.e. southeast on the compass).*

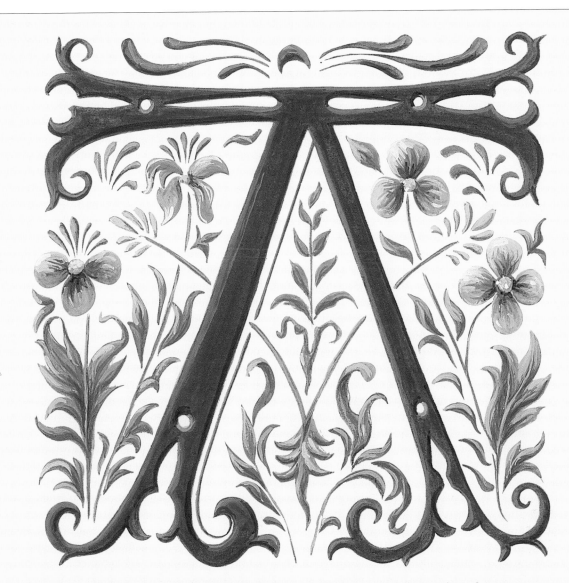

The final step is to add highlights on the opposite side to the shadows: touches of white with a tinge of pink on the flower petals; a very pale green on the foliage; and for the initial itself, an orangey tint using some yellow and light cadmium red.

Experimenting with colour

Initial I using shades of green

Colour variations using an initial by Jean Knoblauk (Germany, 16th century). The most distinctive feature of the Renaissance is the style of the calligraphy: here we have an initial I resembling the faceted lettering carved on Trajan's Column in Rome.

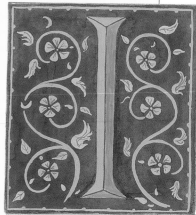

Another sign of classical Roman influence in the 16th century is the symmetrical placement of the garlands around the letter.

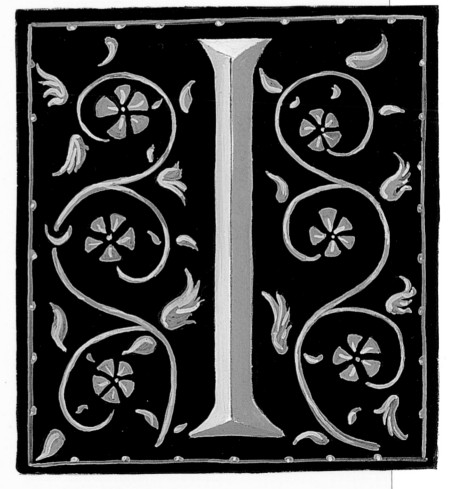

FGHIJK
RSTUV

Alphabet Bamboo

Despite resembling a shrub, bamboo is actually a member of the grass family. For over two millennia it has enjoyed a reputation based on its many practical uses. It is employed in making plates, domestic utensils, flooring, musical instruments, bamboo stilt-houses and wood pulp as well as having culinary and medicinal applications. Its form and texture has also inspired lettering.

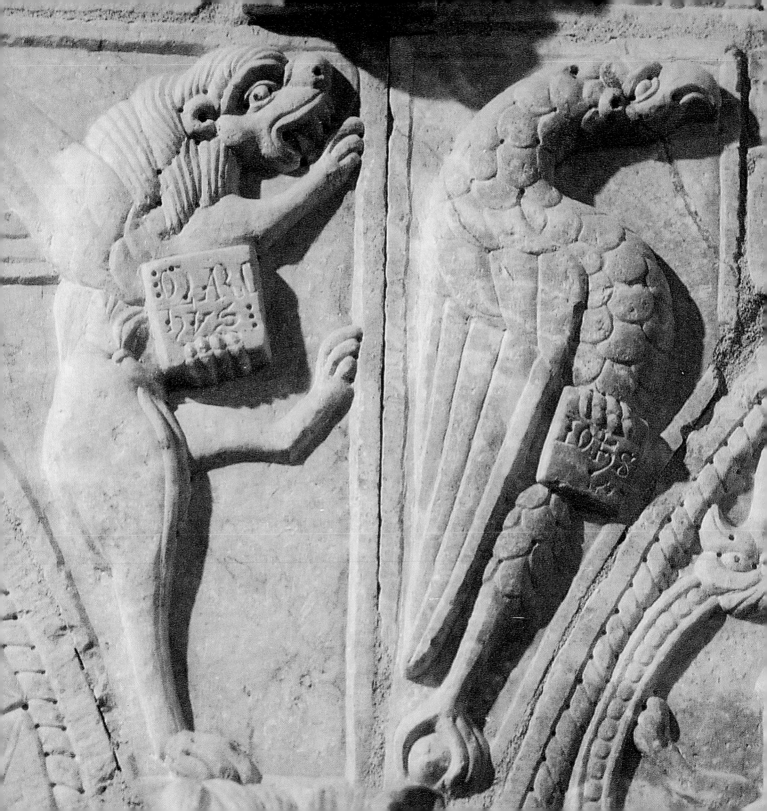

The animal kingdom

Animals are found almost everywhere throughout medieval culture; from everyday life, songs and poetry, to the Bible and travellers' tales. They also occur frequently in decorated initials which are consequently known as 'zoomorphic'. The diversity of their representation is a testament to the ingenuity of the illuminators; designs vary from Celtic beasts with twisting spirals for beaks and feet, to the fabulous hybrid creatures of the Orient — as well as the more naturalistic portrayal of animals in the Renaissance period. All creatures great and small can be found: birds, mammals, fish and insects.

Constructing a motif

Perched bird within initial Q

This decorated initial is from a 15th-century alphabet printed from a woodblock; this is the same alphabet used for the convolvulus on pages 20–21.

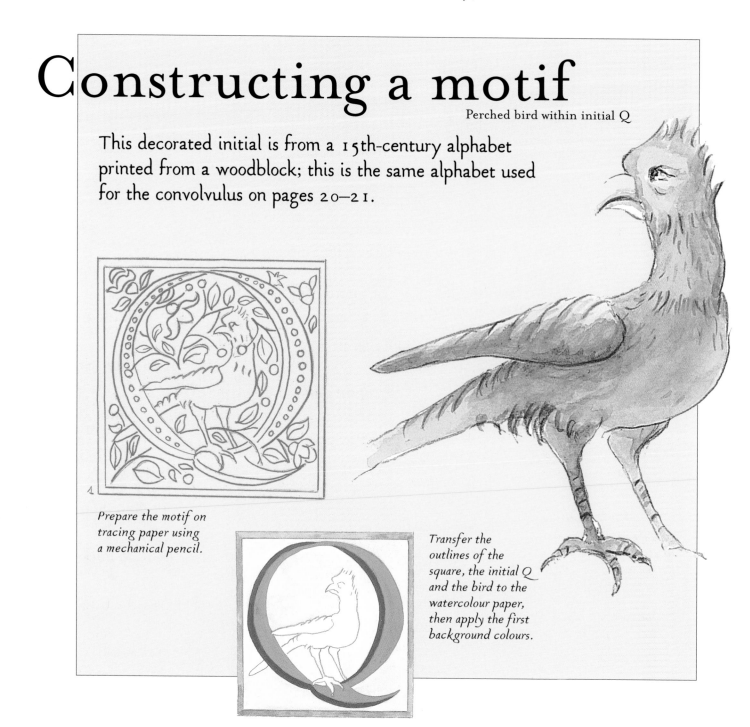

Prepare the motif on tracing paper using a mechanical pencil.

Transfer the outlines of the square, the initial Q and the bird to the watercolour paper, then apply the first background colours.

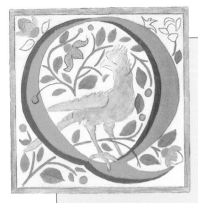

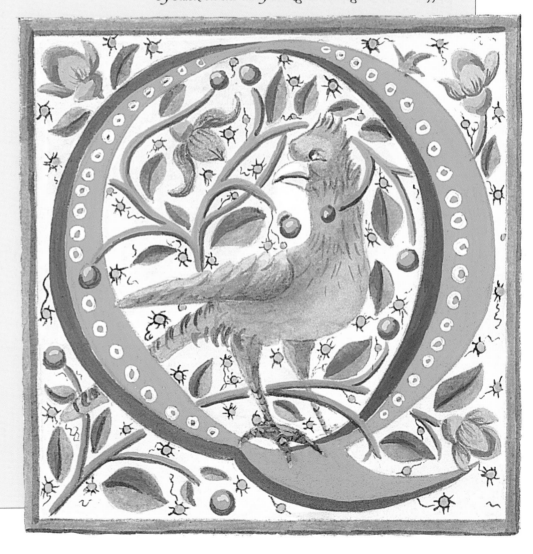

Finish by adding highlights on the opposite side to the shadows, then adding a few points of orange surrounded by black on the ivory background to give a denser effect.

Again, use tracing paper to trace the outlines of the flowers and foliage, then add the mid-tones.

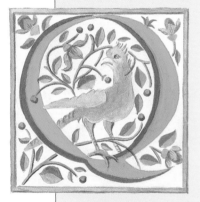

Add the shadow tones to each element: darker tones inside the flowers, on the outer edges of the oranges, and below the bird's wing and neck.

Experimenting with colour

Blue lobster within initial O

These examples of colour combinations based on a tiled background are from a medallion in the *Heures à l'usage de Rome* (mid-15th century; Pierpont Morgan Library, New York). The blue lobster, still alive, crawls across squares painted in perspective. Red and yellow squares heighten the contrast with the animal: blue and green blend in with it.

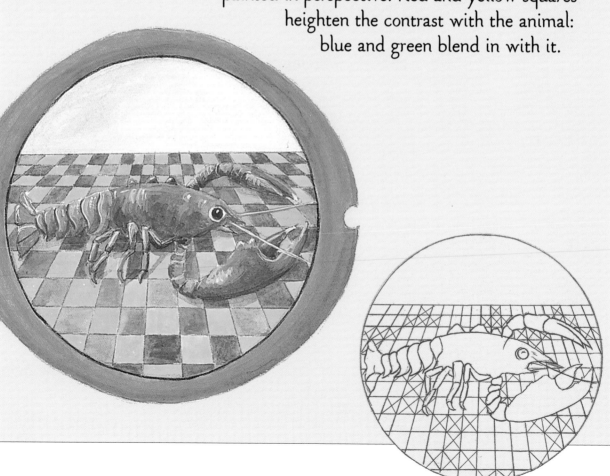

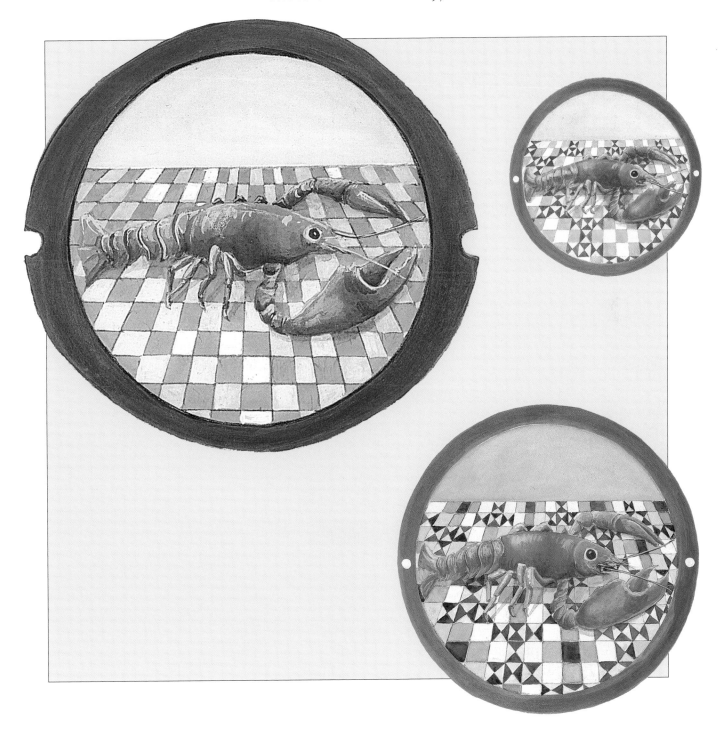

Experimenting with form

Gellone Sacramentary

The iconography of the *Gellone Sacramentary* manuscript (late 8th century) includes many initials decorated with representations of animals: rams, wild boar, fish and various birds are contorted to fit into the initials. The influence of the insular Irish illuminators is visible here in the use of a restrained range of red, yellow and green and the mixture of naturalistic, fantastic and stylised creatures.

Constructing a motif

Performing bear with keeper within initial C

This initial C can be found in St Augustine's *Homilies on St John's Gospel* (early 12th century), which was originally from the cathedral of Saint-Gatien, Tours; and is now in the city's public library. The bear was regarded as the king of the Germanic and Celtic forests.

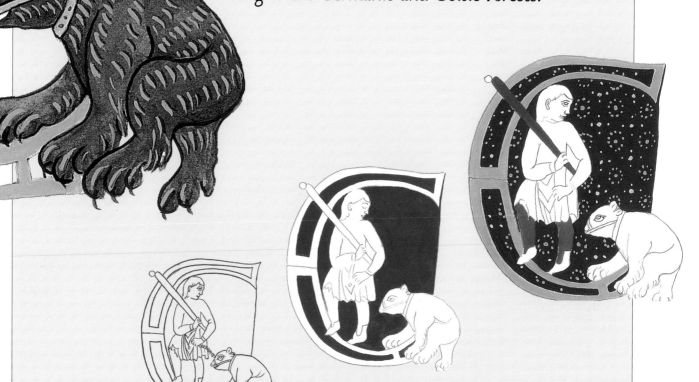

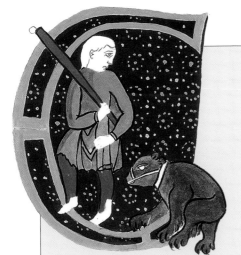

The Church sought to demystify this fearsome animal, which figures prominently in pagan cults, and had no qualms about showmen with performing bears. The animal, chained, docile and obedient, became very different from the wild creature venerated by northern peoples.

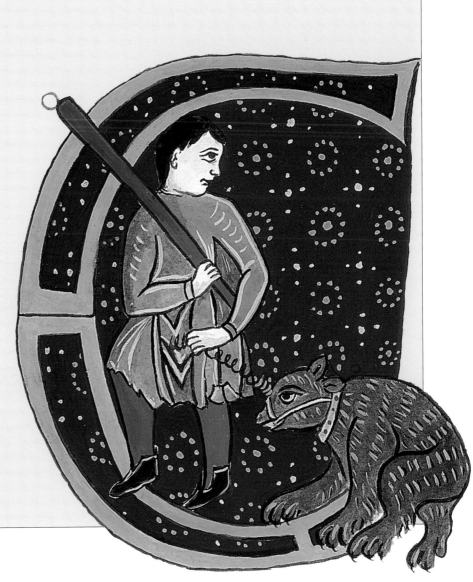

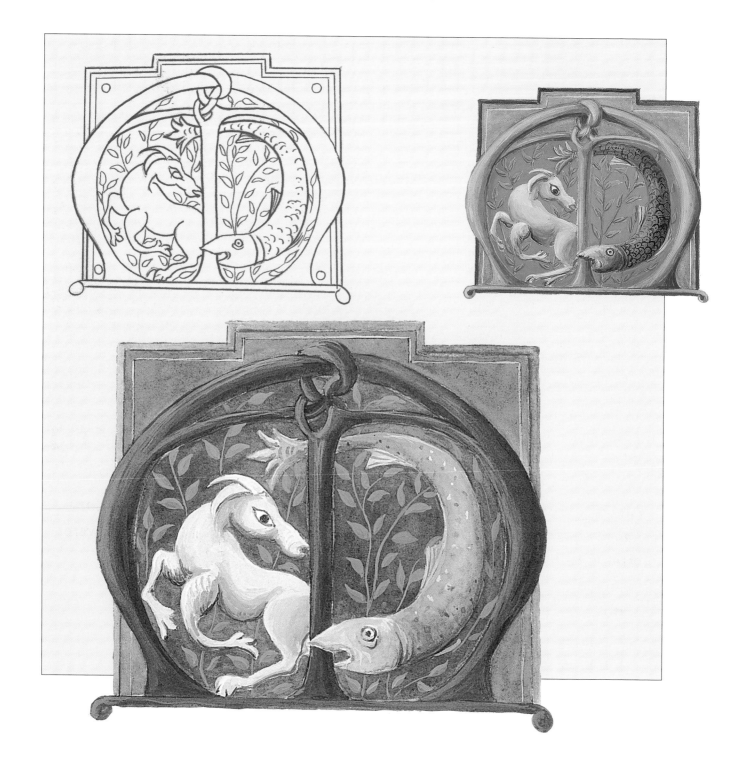

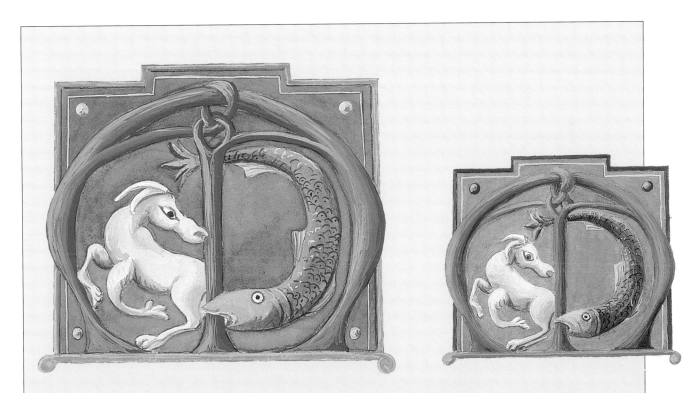

Experimenting with colour

Ram and fish within initial M

An original design based on a ram and a fish, both taken from the *Gellone Sacramentary*. To shape them into or fit them inside a letter, animals were often given stylised forms. Some are no longer recognisable, their eyes enlarged to make them look more human. Sometimes two worlds are juxtaposed: here land (ram) and sea (fish).

Experimenting with form

Beehive letters

These designs were inspired by the Beehives miniature in the *De Proprietatibus Rerum* by Barthélemy L'Anglais, a manuscript of 1447 now in the Amiens public library. This was undoubtedly the most popular of the medieval encyclopaedias.

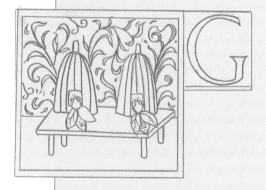

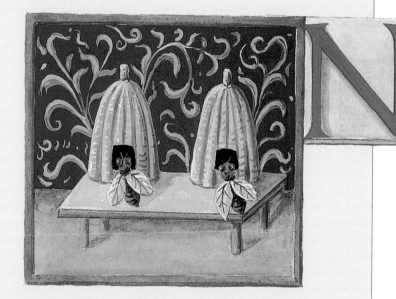

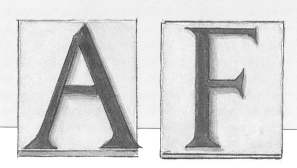

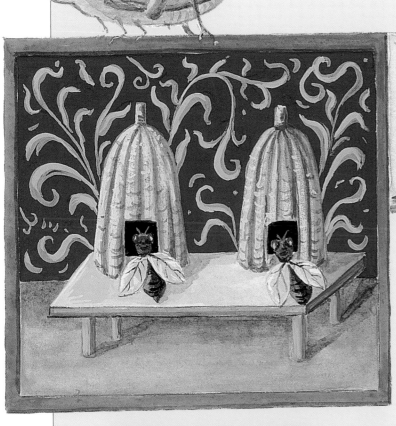

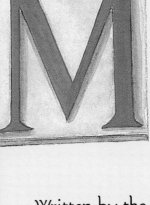

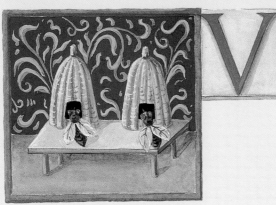

Written by the Franciscan monk Barthélemy between 1230 and 1240, it became a standard work and is preserved in over two hundred Latin manuscript versions. In nineteen books, the author describes the properties of everything in creation: God, angels, souls, Man, the heavens, weather, birds, water, mountains, insects, and so on.

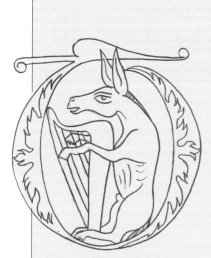

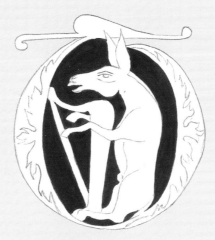

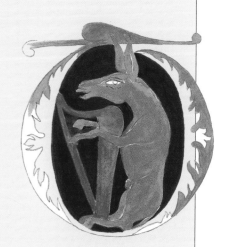

Transfer the basic motif using tracing paper.

Fill in the background using cadmium red with a touch of ultramarine.

Carefully following the outlines, put in the mid-tones.

Constructing a motif

Musical donkey within initital T

Sitting on his hindquarters and scraping the strings of the lyre with his hooves, this donkey could be seen as a joke, his playing as discordant as his voice. Some, however, have seen in this image a warning against pride. The original initial was an O in the *Sermones* of Petrus Comestor (early 13th century), replaced here by a T in the uncial style.

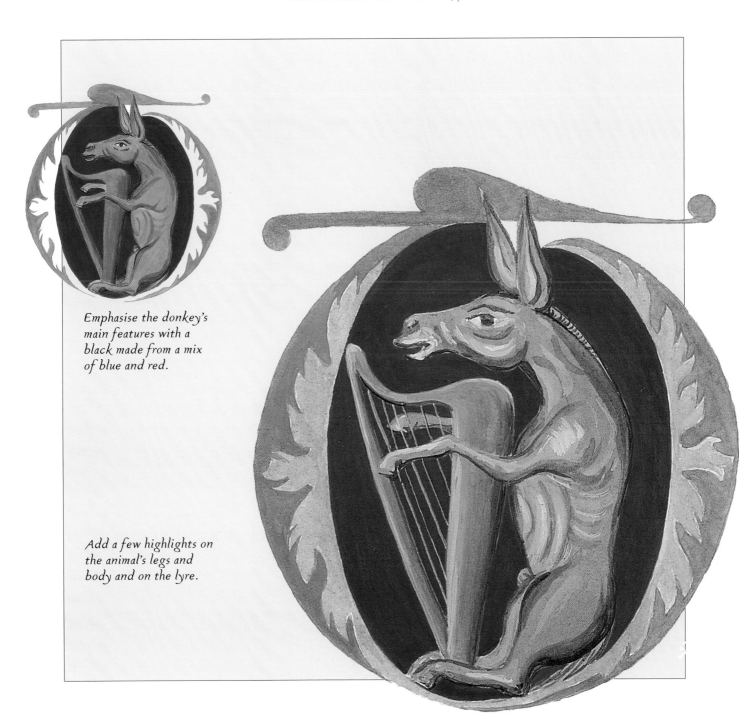

Emphasise the donkey's main features with a black made from a mix of blue and red.

Add a few highlights on the animal's legs and body and on the lyre.

Experimenting with colour

Tame bird of prey within initial D

Here we find colour variations based around a D. The knot motif forms the upright part of the letter while the body of the bird of prey — perhaps an eagle — forms the rounded part of the initial.

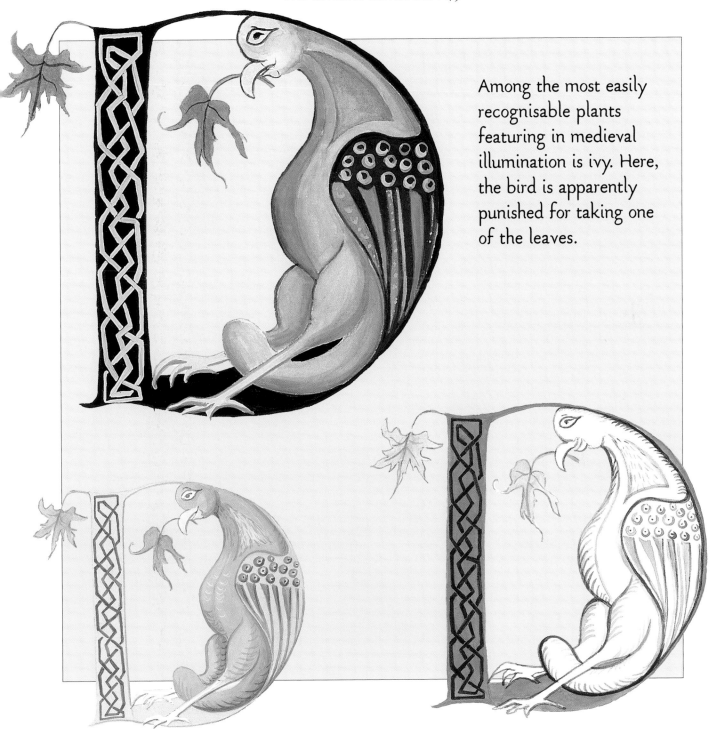

Among the most easily recognisable plants featuring in medieval illumination is ivy. Here, the bird is apparently punished for taking one of the leaves.

Griffon with claws of eagle and lion from a miniature in the De Proprietatibus Rerum *of Barthélemy l'Anglais, 1447.*

Griffon, from a 9th-century Bible.

Lion and rabbit from the margin of a 15th-century miniature.

Prototype of winged lion: the head has not yet become an eagle's.

Fabulous animals

from the lion to the griffon

The griffon is a fabulous beast with an eagle's beak and wings and a lion's body, a denizen of both earth and sky. It represents Persia; and in Greek myths it is a monster guarding treasure. Its function in medieval symbolism is to illustrate the double nature of Christ, human and divine.

the unicorn

The myth of the unicorn originated in the Orient, and in ancient China represented royalty. In medieval iconography it is the symbol of power and chastity and can only be caught with the aid of a pure virgin. It is often placed beside the lion in heraldry. The six tapestries of *The Lady and the Unicorn* woven *c.* 1500 in Flanders have immortalised this animal. Five of the six panels represent our five senses; the enigmatic sixth may signify renunciation of the passions.

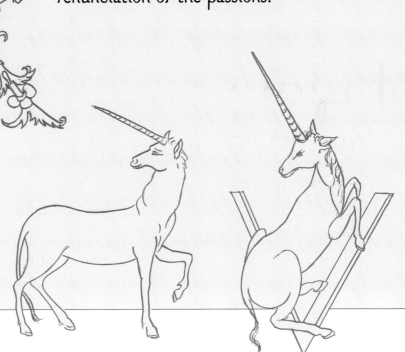

the dragon

The dragon has featured in the culture of most civilisations, both as villain and hero. As a reptile it belongs to the land, but can also swim and usually has wings to aid its escape. It is often portrayed breathing fire. The dragon's principal occupation was guarding treasure and killing anyone who tried to steal it. As times turned more violent, the dragon became a creature of evil, a destructive force. Christianity would adopt this symbol of terror, representing the dragon as the incarnation of Satan.

Dragon with curled tail, from a 15th-century Franciscan breviary.

Initial L with fire-breathing dragon (15th century).

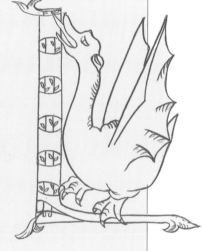

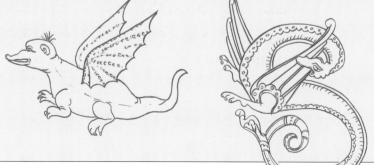

Dragon in form of an S from a 12th-century ms.

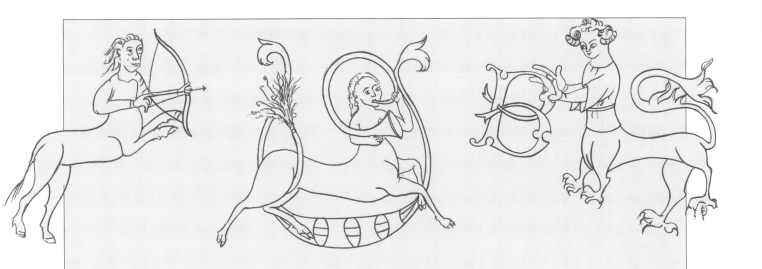

From centaur to constellation

Half-man, half-horse, the centaur of Greek mythology dwelt in the mountains and forests and was notorious for his brutality and lechery. The constellation Sagittarius (the Archer) derives from the legend of Chiron, an exceptional centaur endowed with great wisdom. He was tutor to Achilles, Jason and Hercules. When he was accidentally wounded by Hercules, Zeus immortalised him as a constellation. Chiron is frequently portrayed holding his bow, a symbol of learning and knowledge.

Stylised
initials

The plant and animal kingdoms were the first sources of inspiration for ornamental lettering — stems could be made to twine at will and animals to contort their bodies to suit the letter. Sometimes the origin is lost to us: the original animal or plant becomes unrecognisable as an abstraction of curling lines. Illuminators also drew heavily on the repertoire of ironwork, architecture and embroidery for these extremely stylised and beautiful ornamental letters.

Constructing a motif

Initial D with perspective effect

The letter D, like P, O and Q, has a circular shape, enabling it to contain a scene. Such initials are described as 'historiated' and most frequently illustrate passages from the Bible.

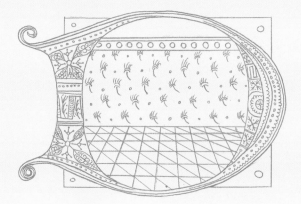

Prepare your design on tracing paper using a mechanical pencil.

Transfer the outlines of the D to the drawing paper along with the frame and the horizon line of the tiled foreground. Choose the mid-tones; the blue for the initial is a blend of ultramarine and cobalt blue with touches of cadmium red and white.

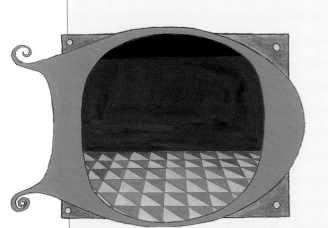

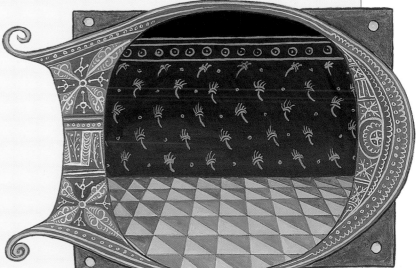

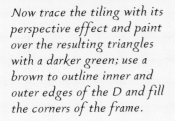

Now trace the tiling with its perspective effect and paint over the resulting triangles with a darker green; use a brown to outline inner and outer edges of the D and fill the corners of the frame.

Reposition your tracing paper, trace the lace motif and transfer it to the initial. Use a pale blue and a very fine brush to colour the surfaces of the stylised leaves; then add the markings with a near-white blue. To finish, add the orange motifs of the background hanging.

The colours of these filigree letters are simple. Originally produced using inks, gouache is a perfect subsititute. The usual combinations are ultramarine or dark cobalt blue, plus vermilion (light cadmium) red or sepia. Use a very fine, good quality brush to avoid errors.

Experimenting with colour

Filigree initial S

Filigree lettering is a 12th-century invention. It consists of a coloured initial surrounded by thread-like motifs with no upstrokes or downstrokes. Decorations form a network of varying degrees of complexity overflowing the frame of the letter into the margins. This type of work was normally carried out in pen on an unpainted background with red, blue or sepia inks. The colour schemes for this S are from a 15th-century manuscript of the *Historia Contra Paganos* by Paulus Orosius.

Experimenting with form

'Trellis'-type initials

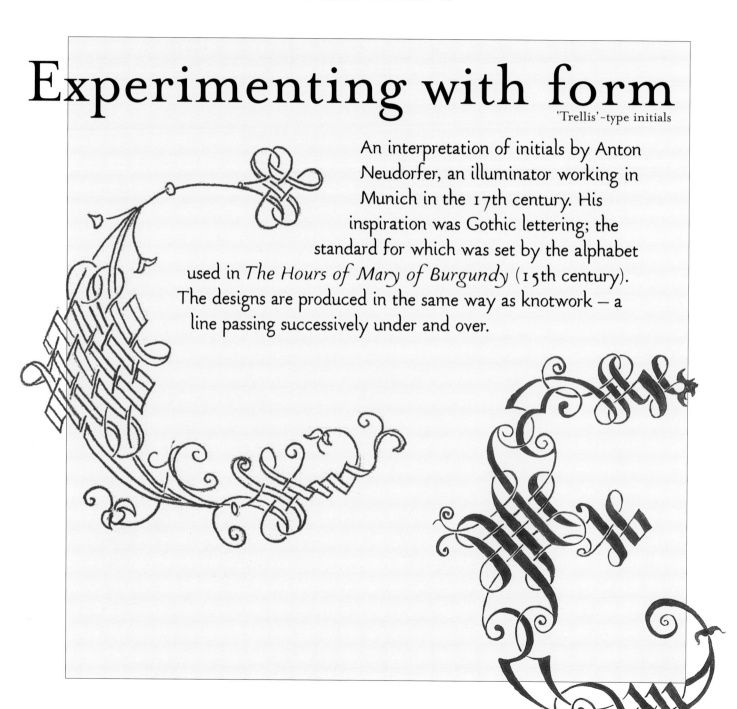

An interpretation of initials by Anton Neudorfer, an illuminator working in Munich in the 17th century. His inspiration was Gothic lettering; the standard for which was set by the alphabet used in *The Hours of Mary of Burgundy* (15th century). The designs are produced in the same way as knotwork — a line passing successively under and over.

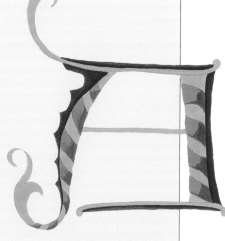

Trace the initial using a mechanical pencil and transfer it to the watercolour paper.

Add all the mid-tones, carefully following the outlines: orange (light cadmium yellow plus light cadmium red), ochre (dark cadmium yellow and ochre) and a garnet shade (dark cadmium red with a touch of ultramarine and yellow).

Add the shadow. Use a dark cadmium red glaze on the orange; ultramarine and dark cadmium red on the garnet.

Constructing a motif

Ribboned initial A

The ribbon is a recurrent motif in ornamental lettering. In the 15th century, as with this A, it was wrapped quite tightly round the structure of the letter. Nineteenth-century ornamentalists, on the other hand, depicted it in a looser fashion. (See the chapter on Monograms: loose ribbon, page 91.)

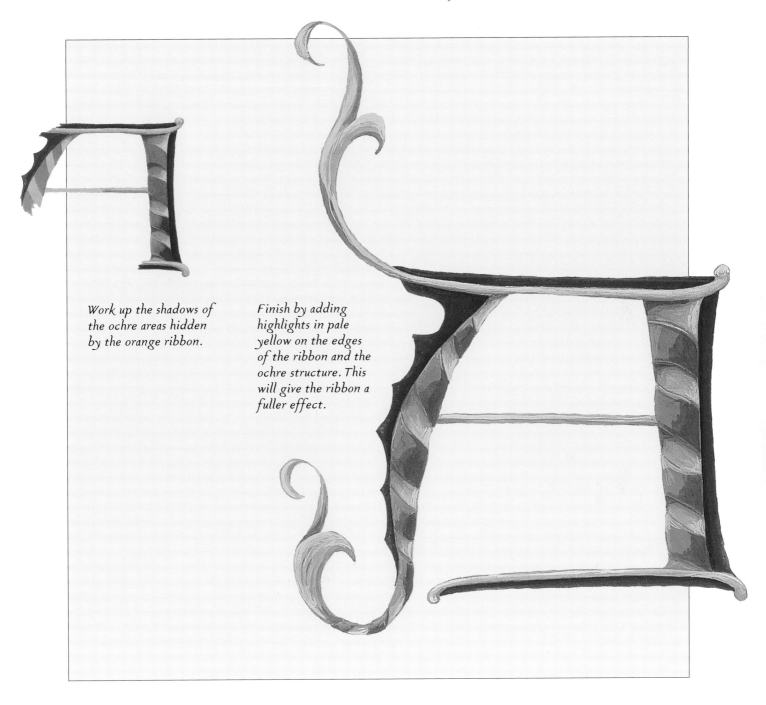

Work up the shadows of the ochre areas hidden by the orange ribbon.

Finish by adding highlights in pale yellow on the edges of the ribbon and the ochre structure. This will give the ribbon a fuller effect.

Experimenting with colour

Renaissance initial H

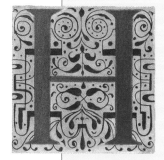

A brown and ochre variation on a Renaissance H from the early 16th century. The Roman-style writing is easily recognisable, rectilinear and looks almost as if carved in stone. The background is composed of arabesques, a classic Renaissance motif filling the surface symmetrically with its delicately sinuous patterns. The arabesque is a highly stylised form of plant motif.

To construct this initial, trace the square and the outlines of the H, then colour in the solid background. Transfer the arabesque motif with the aid of tracing paper and a mechanical pencil; then go over the pencil lines with gouache, using a very fine brush.

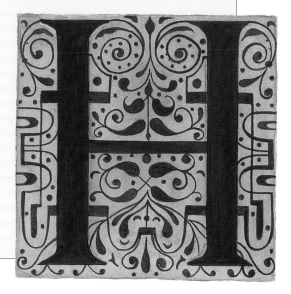

Experimenting with form

Green centre

Designs for initials O, P, Q and U, based on a form of uncial writing characterised by its rounded letters. The green centre is a combination of scrolls and stylised leaves and is fairly typical of the 15th century.

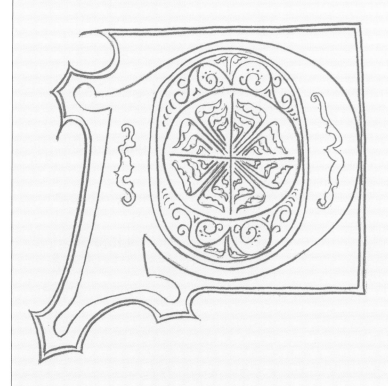

It's simple enough to create these initials. Transfer the trace of the frame and letter and put in the background colours: an ochre earth, a yellowy pink and a brown. Mark the outline of the letter and frame with the same brown. Transfer the heart motif with pencil and tracing paper; using a very fine brush go over the patterns with a light green. Use the same green to delineate the inside edge of the frame.

Constructing a motif

Initial M with long descender

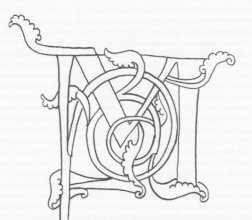

Two of the characteristics of Gothic lettering are the presence of a network of highly stylised plant tendrils and the introduction of light and shadow effects. This M with exaggerated descender is from a manuscript of the 14th century.

After transferring the drawing to the watercolour paper, first paint the background blue, then paint the mauve letter (ultramarine plus dark cadmium red with a touch of white), and finally the pink and green spirals.

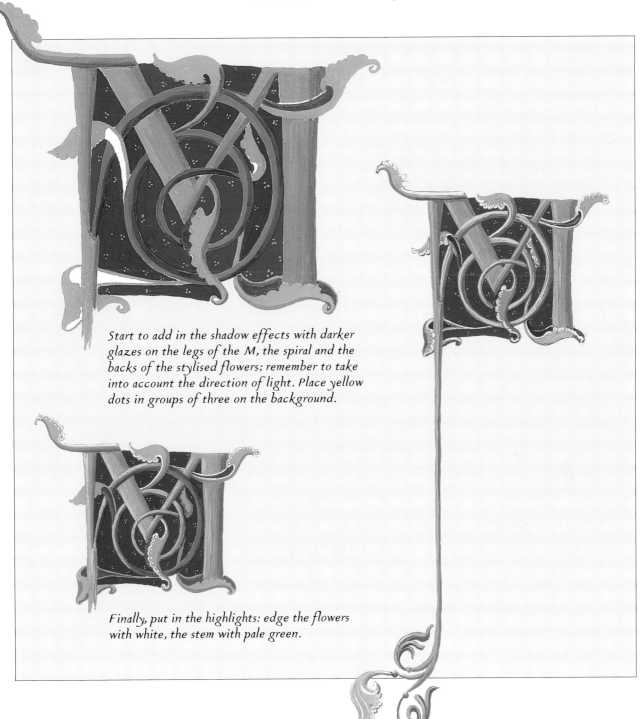

Start to add in the shadow effects with darker glazes on the legs of the M, the spiral and the backs of the stylised flowers; remember to take into account the direction of light. Place yellow dots in groups of three on the background.

Finally, put in the highlights: edge the flowers with white, the stem with pale green.

A
B
C
K
L
R
S

Alphabet *Uncial*

Uncial is a very old style of
writing dating back to the 4th
century BC. This example is from
14th-century Germany.

D

E

F

H

M

N

O

P

T

U and V

W

Z

'Uncial' derives from the Latin word *uncia* meaning 'inch', this being the usual height (2.5 cm) of the first letters. This type of writing, with its rounded capitals, continued to be used until the 8th century.

Alphabet *Wrought iron style*

From a 12th-century alphabet. Here, various forms of ornamentation are combined: stars, curlicues and rectilinear motifs rub shoulders with organic scrolls so stylised as to resemble designs for wrought ironwork. Such lettering was usually painted either in pure red or blue or else gilded.

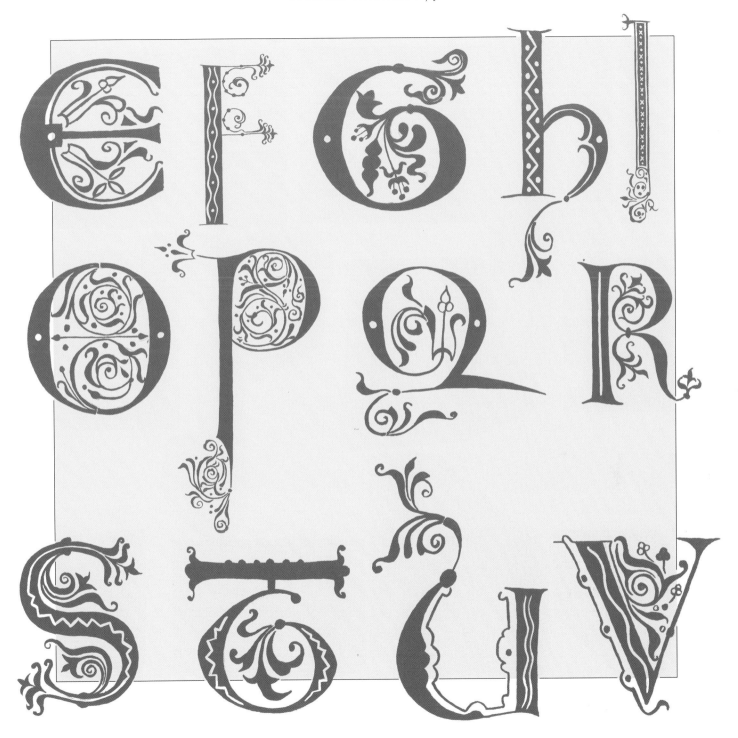

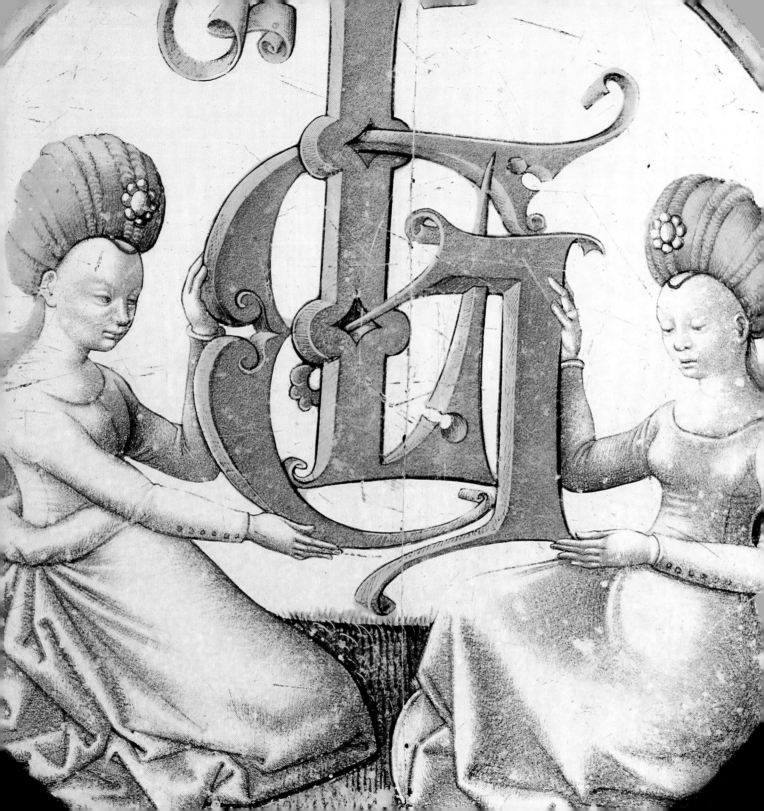

Monograms

The monogram, a device composed of (often interlacing) initials, is very ancient: examples appear on the coinage of Heraclea; medieval masons' guilds accompanied their monograms with special motifs (a cross, for instance); while monarchs employed symbolic designs such as a crown. The monogram stresses property and status, and from the early Renaissance ornamentation of monograms became more florid.

Experimenting with form

Monograms with tassels

The inspiration for these examples is an A–Y monogram found consistently in the frames of miniatures by the Master of Antoine Clabault, an alderman of Amiens who married Ysabeau Fauvel in 1464. The Gothic characters are linked by a tasselled cord. The manuscript is now in the possession of the Bibliothèque de l'Arsenal, Paris.

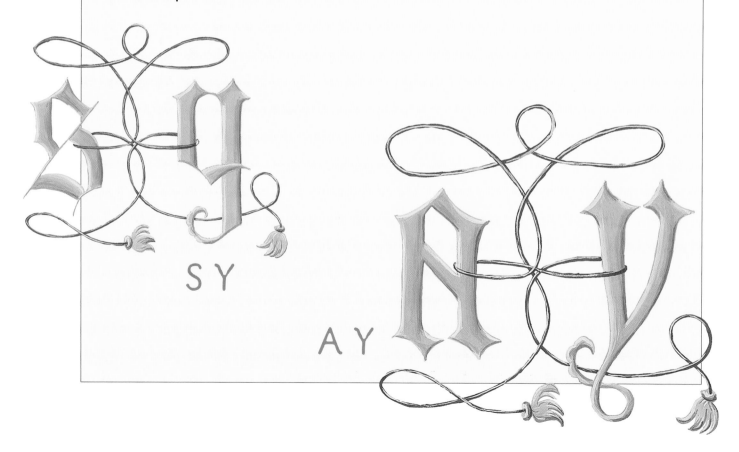

S Y

A Y

The main characteristics of Gothic lettering are:
– It is rectilinear, rather than sinuous like Carolingian
– The writing is very cramped and somewhat elongated vertically, rendering it hard to read.

I H

B N

R O

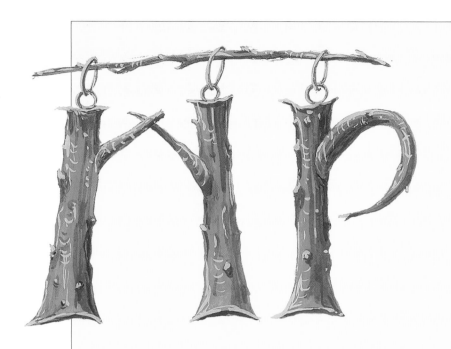

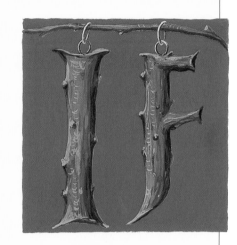

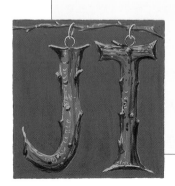

Experimenting with form

Hanging branches

Medieval illuminators frequently astonish us not only with the freshness of their colours but also with their unbridled imagination. Their disregard for proportion, for instance, can result in a monkey perching on the frail branches of a plum tree, while their delight in bizarre juxtapositions might produce a rabbit riding on a lion.

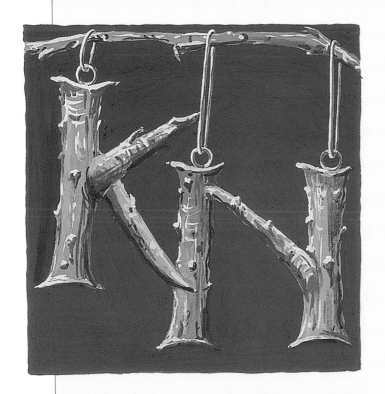

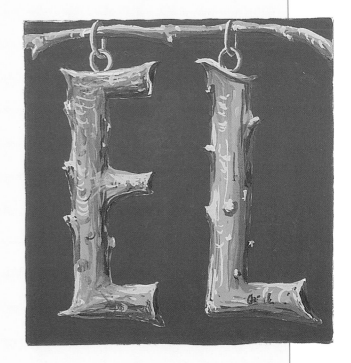

Here, wooden logs, such symbols of weight and strength, are suspended from much lighter branches by thin rings — and the branch doesn't even bend!

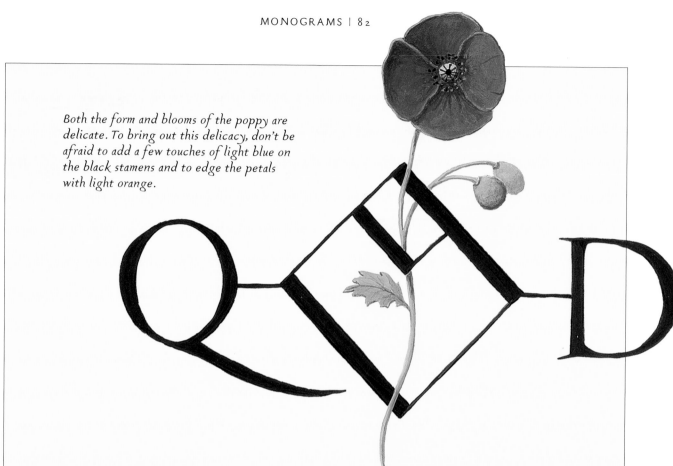

Both the form and blooms of the poppy are delicate. To bring out this delicacy, don't be afraid to add a few touches of light blue on the black stamens and to edge the petals with light orange.

Experimenting with form
The poppy

The wild poppy is frequently found gracing the borders of miniatures. The manuscript of the *Great Hours of Anne of Brittany* is a real goldmine for the modern illuminator looking for ways to depict the flora of garden and countryside.

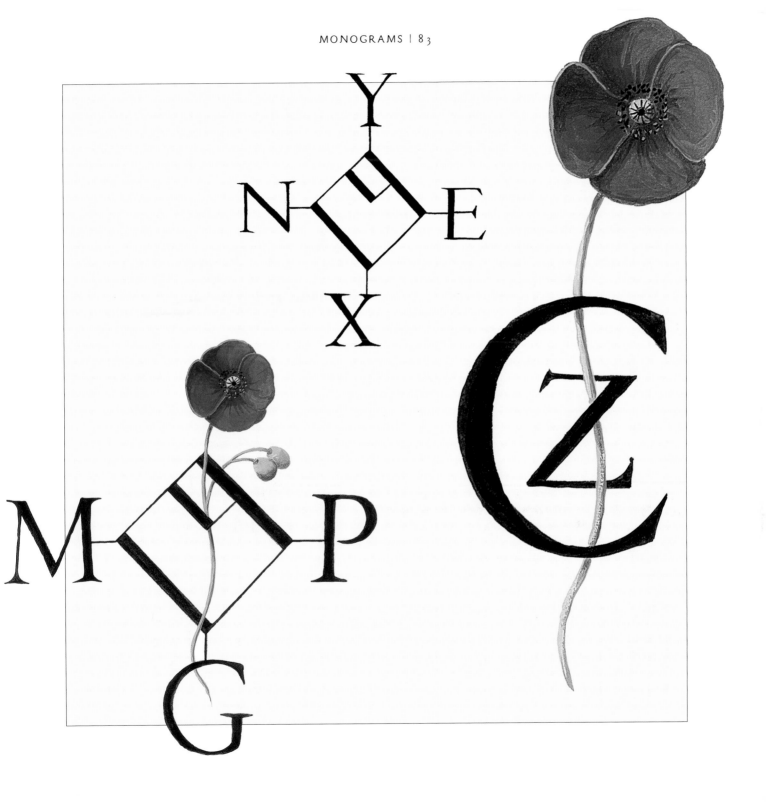

Experimenting with form

The ladybird

There is often an artistic subtext with decorated letters; sometimes it underlines the symbolism; at others it is quite incongruous. Here, ladybirds have landed on a banner blowing in the wind.

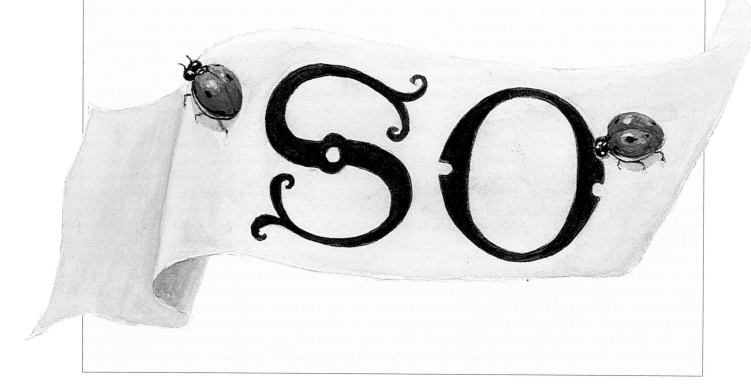

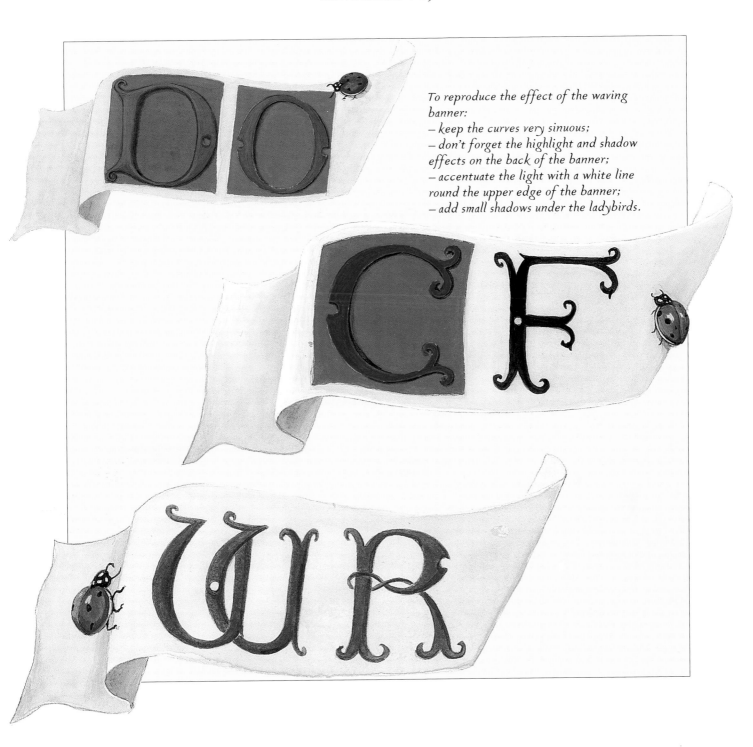

To reproduce the effect of the waving banner:
— keep the curves very sinuous;
— don't forget the highlight and shadow effects on the back of the banner;
— accentuate the light with a white line round the upper edge of the banner;
— add small shadows under the ladybirds.

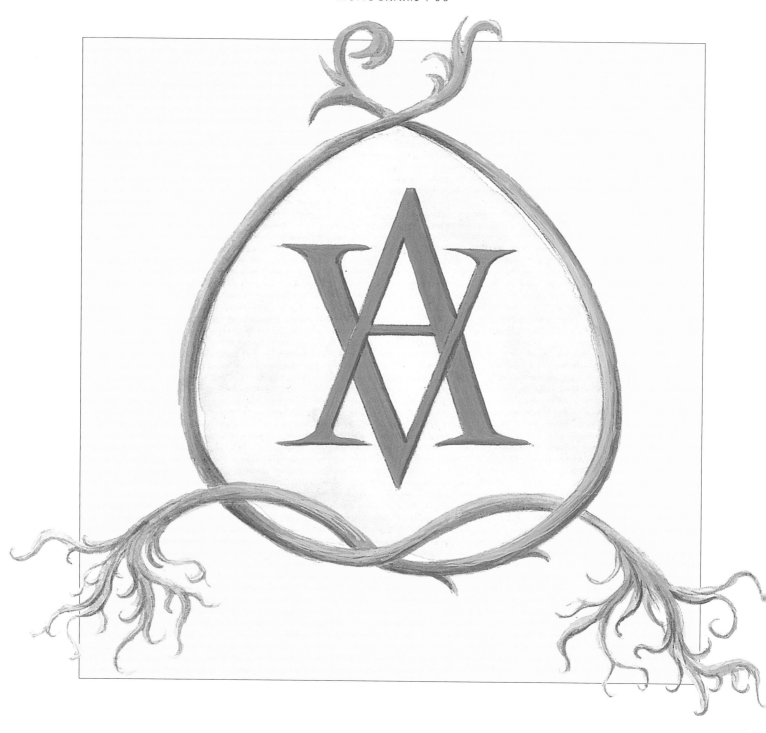

Experimenting with form

Organic medallion

In its original form, this medallion, composed of interlaced branches and roots, featured a historiated scene from the margins of the *Breviary of John, Duke of Bedford* (early 15th century). With the original image removed, the branches make an ideal border for incorporating monograms of interlinking letters.

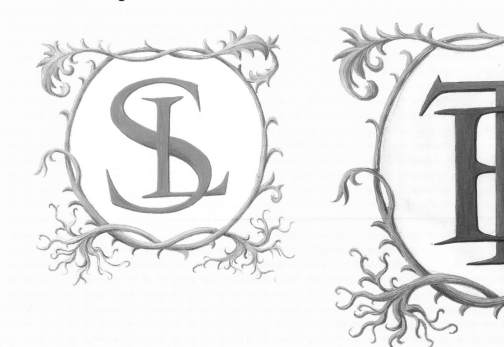

Experimenting with form

Filigree monograms

These monograms composed of initials are based on manuscripts of the 13th to 15th centuries. The word 'filigree' comes from two Italian words meaning 'thread' and 'grain'. Here are a few filigree letters, one with a terminal in the form of a human head.

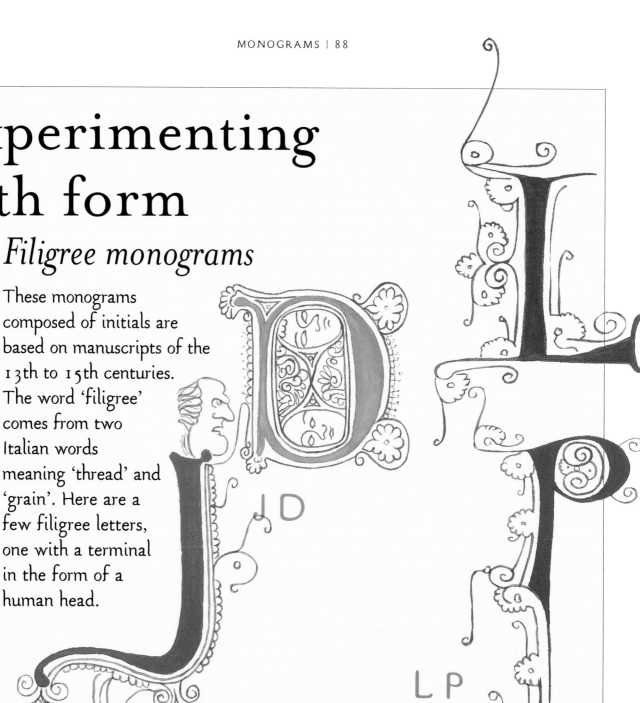

A B E

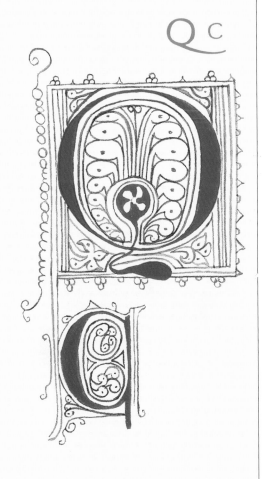

Q c

In ancient times many items of jewellery were fashioned using the filigree technique: wire made of precious metal, particularly gold, was twisted and soldered into a design.

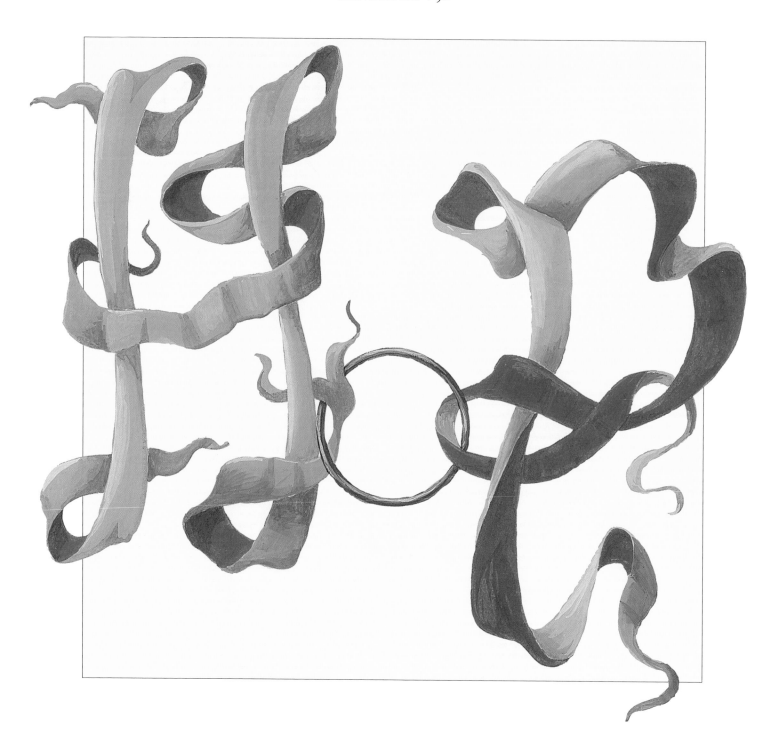

Experimenting with form

Loose ribbon

H–P, A–J, F–M and V–L, each made up of two-coloured ribbons linked by a ring. These letters are inspired by a 19th-century alphabet.

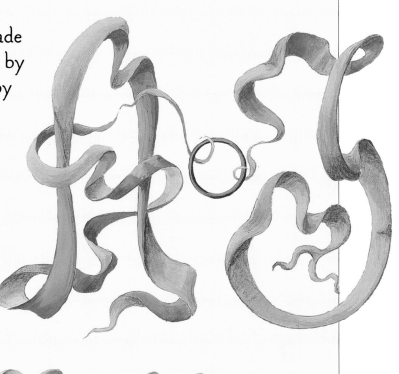

To make things more fun, vary the colours on the surfaces of the ribbons; it also helps you to understand their arrangement. Don't forget to add shadows wherever the ribbon twists.

Experimenting with form

Small chequerboard designs

The small chequerboard designs suggested here resemble old-fashioned glazed earthenware tiles, and make a good contemporary alternative to the trellised or diamond patterns used as a background in Gothic illumination.

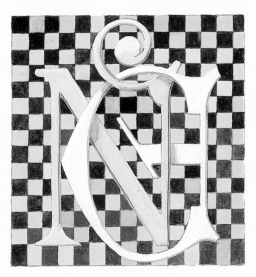

To make the design:
– draw the squares with a ruler and mechanical pencil and cover entirely with a light yellow;
– transfer the lettering using tracing paper;
– begin adding the red/pink, varying the exact shade at random between different squares;
– finally, paint the letters and make any necessary adjustments to the outlines of the red and yellow squares.

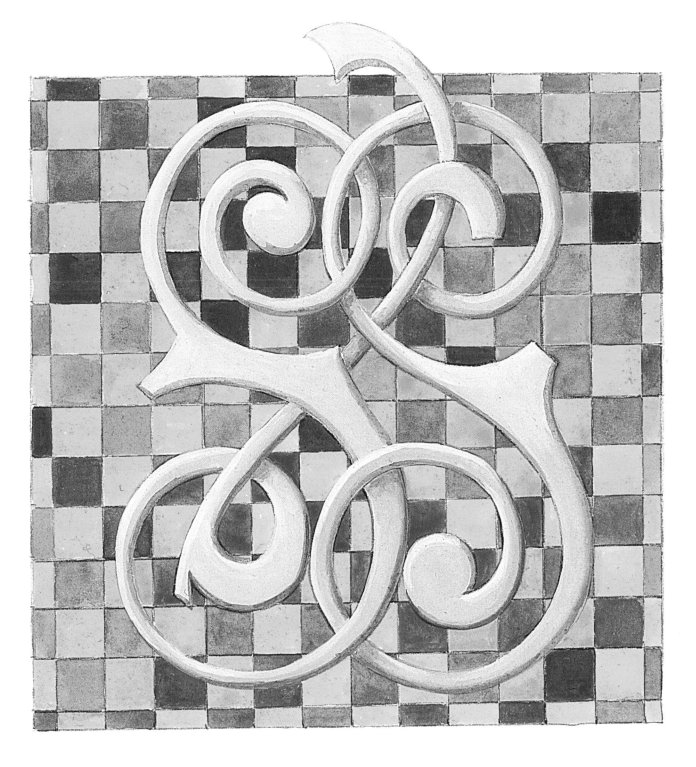

Templates

Flowers, leaves and branches

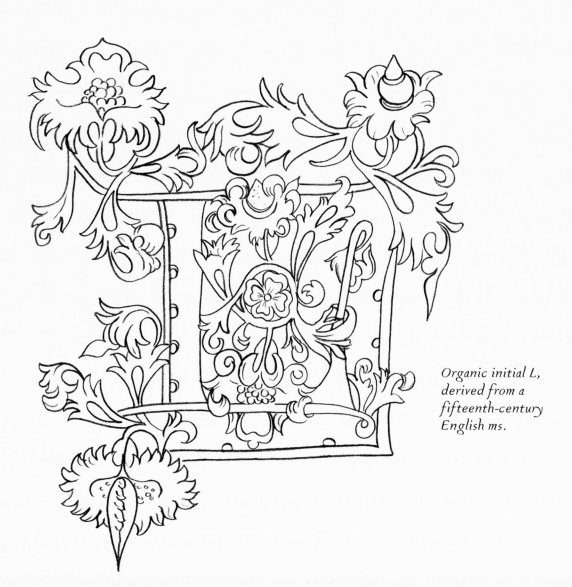

Organic initial L, derived from a fifteenth-century English ms.

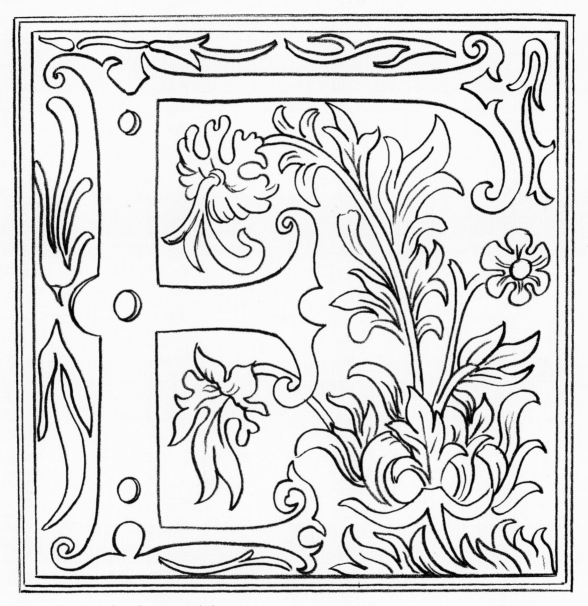

Initial F as used in the Roman de la Rose.
This example is from a sixteenth-century French work.

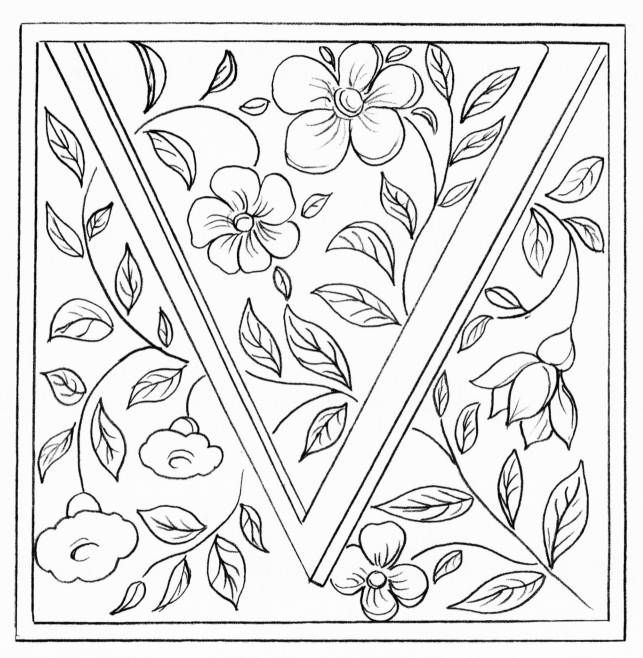

Initial V with convolvulus.
Inspired by an illuminated capital engraved on wood,
this V displays typical Renaissance classicism.

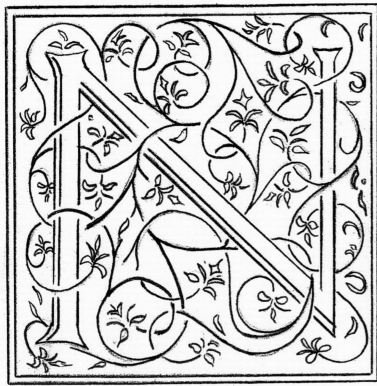

Initial N with white vine.
The letter is interlaced with a clambering
vine, traditionally white on a coloured
background. This example is from a
sixteenth-century French work.

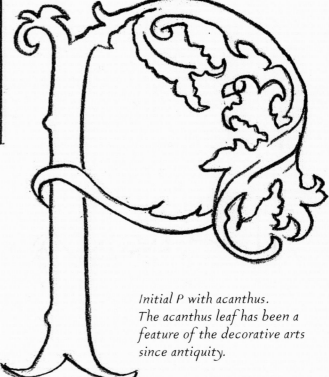

Initial P with acanthus.
The acanthus leaf has been a
feature of the decorative arts
since antiquity.

The animal kingdom

Initial D in the form of a tame hawk. The bird's back blends into the curve of the letter.

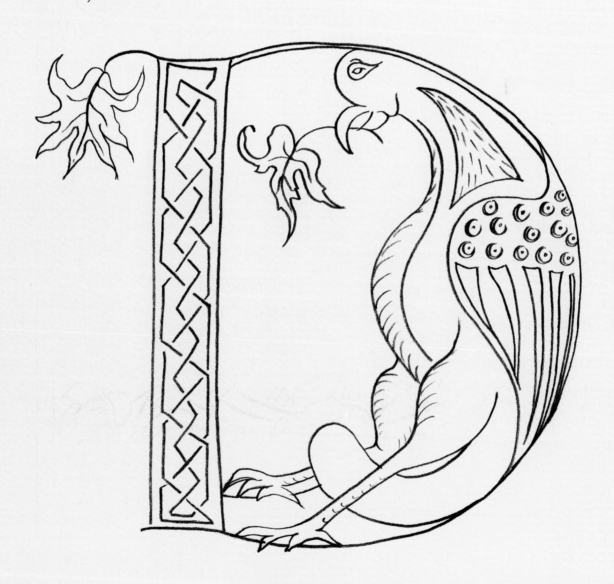

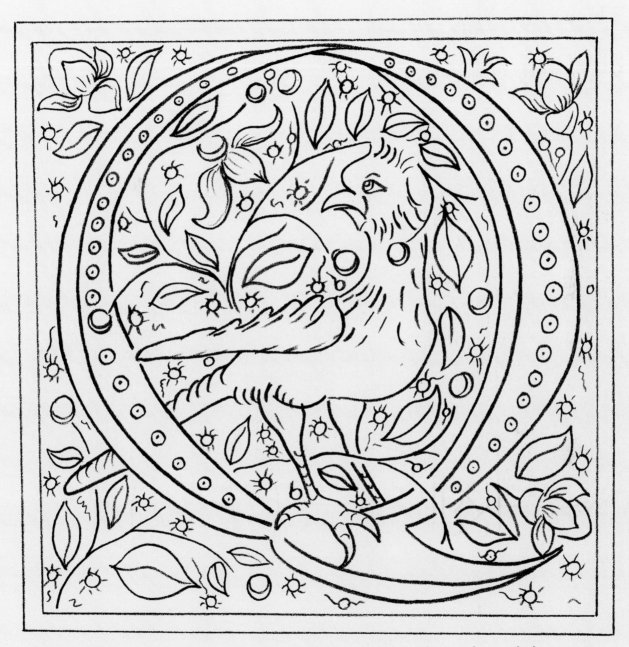

Initial Q with perching bird. This letter is from the same alphabet as the V with convolvulus on p. 96.

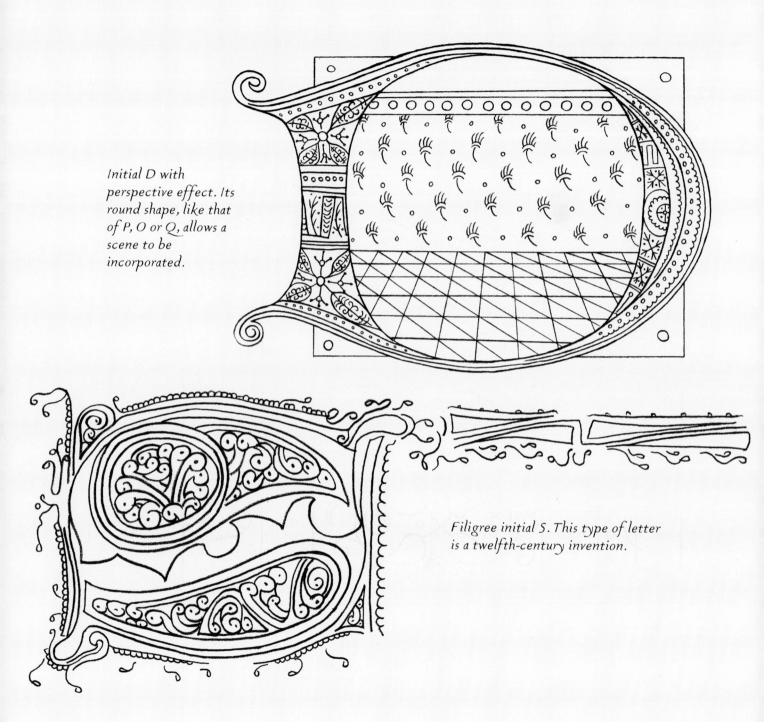

Initial D with perspective effect. Its round shape, like that of P, O or Q, allows a scene to be incorporated.

Filigree initial S. This type of letter is a twelfth-century invention.

Stylised letters

Renaissance initial H. The organic
elements of this sixteenth-century
letter are highly stylised.

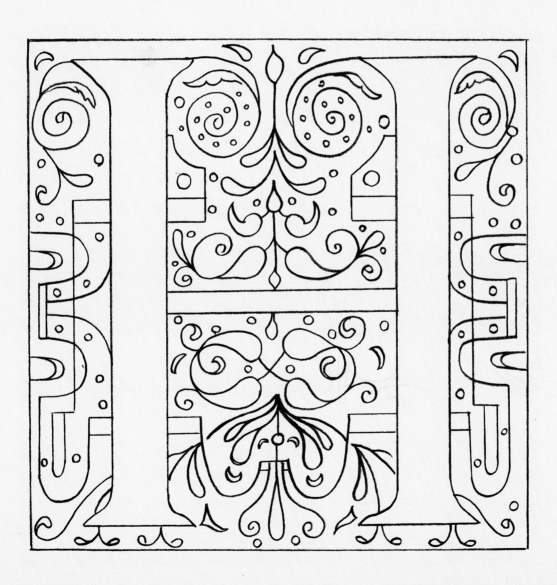

Glossary

ANTIPHONARY – chant-book for the Mass and Daily Offices.

APOCALYPSE – book containing the Revelation of St John the Divine.

BESTIARY – book containing descriptions and anecdotes of real or imaginary animals designed to inculcate strong Christian moral values.

BOOKS OF HOURS – collection of prayers for the use of laymen at the eight canonical hours (religious offices); often also contained psalms and calendars.

BREVIARY – liturgical book containing texts for the canonical hours: prayers, hymns, psalms, and so forth.

CAROLINE – miniscule form of writing with rounded and regular outlines dating from reign of Charlemagne and designed to save time in copying texts.

CODEX (PLURAL CODICES) – the first codices were linked wooden tablets; with the arrival of parchment, leaves were folded and assembled into bound volumes.

COPYIST – person responsible for transcribing a text.

FOUQUET, JEAN (1420–81) – painter and illuminator of the French 15th-century school; his style represents a harmonious synthesis between Flemish and Tuscan influences. Author of the *Hours of Étienne Chevalier* (Grand Treasurer of France), Fouquet was court painter to Louis XI.

GRADUAL – chant-book for the Mass.

HERBAL – manual for physicians dealing with herbs and their medical properties; later versions contained advice on their cultivation together with culinary applications.

ILLUMINATION – from the Latin *illuminare*; the painted and gilded decorations found in manuscripts. The term covers initials, borders and miniatures.

INITIAL – opening letter of a page or paragraph. Decorated versions are known as historiated when incorporating an anecdote and zoomorphic when portraying an animal or fabulous beast.

LIMBOURG (BROTHERS) – Paul, Herman and Jean Limbourg, goldsmiths and illuminators in the early 1400s. Authors of the *Très Riches Heures du duc de Berry* (1412–16) embellished with 172 miniatures and an abundance of historiated initials.

MINIATURE – from the Latin *miniare* meaning 'to colour with red lead'. In today's technical parlance it refers to small pictures in manuscripts other than initials and borders.

PAPER – the word derives from the Latin *papyrus*, meaning a thin sheet of writing material. Paper as we know it is mainly made from vegetable fibres, such as wood pulp; it became common in China in the 2nd century, spreading to Europe in the 11th century.

PAPYRUS – *Cyperus papyrus* is a reed found in great quantity in the Nile valley. Papyrus manuscripts took the form of rolls, making them easy to read, but they wore badly and were sensitive to damp.

PARCHMENT – from the Latin *pergamina charta* ('writing material from Pergamum'). Processed animal hide (usually sheep or goat). The best parchment (*see* VELLUM) is thin and fine-grained, providing better adhesion for inks and pigments.

PSALTER – book containing the 150 psalms of the Old Testament together with prayers, readings and hymns.

RUBRIC – from the Latin *rubrica terra* ('red earth'): indicates chapter headings executed using ink prepared from red lead.

SCRIPTORIUM – area of the a monastery devoted to the copying and illumination of manuscripts.

VELLUM – the finest quality parchment, derived from newborn or stillborn calves, kids or lambs, very fine and very white.

VOLUMEN – from the Latin *volvere* ('to roll'). The roll was the principal form of book during the Middle Ages.